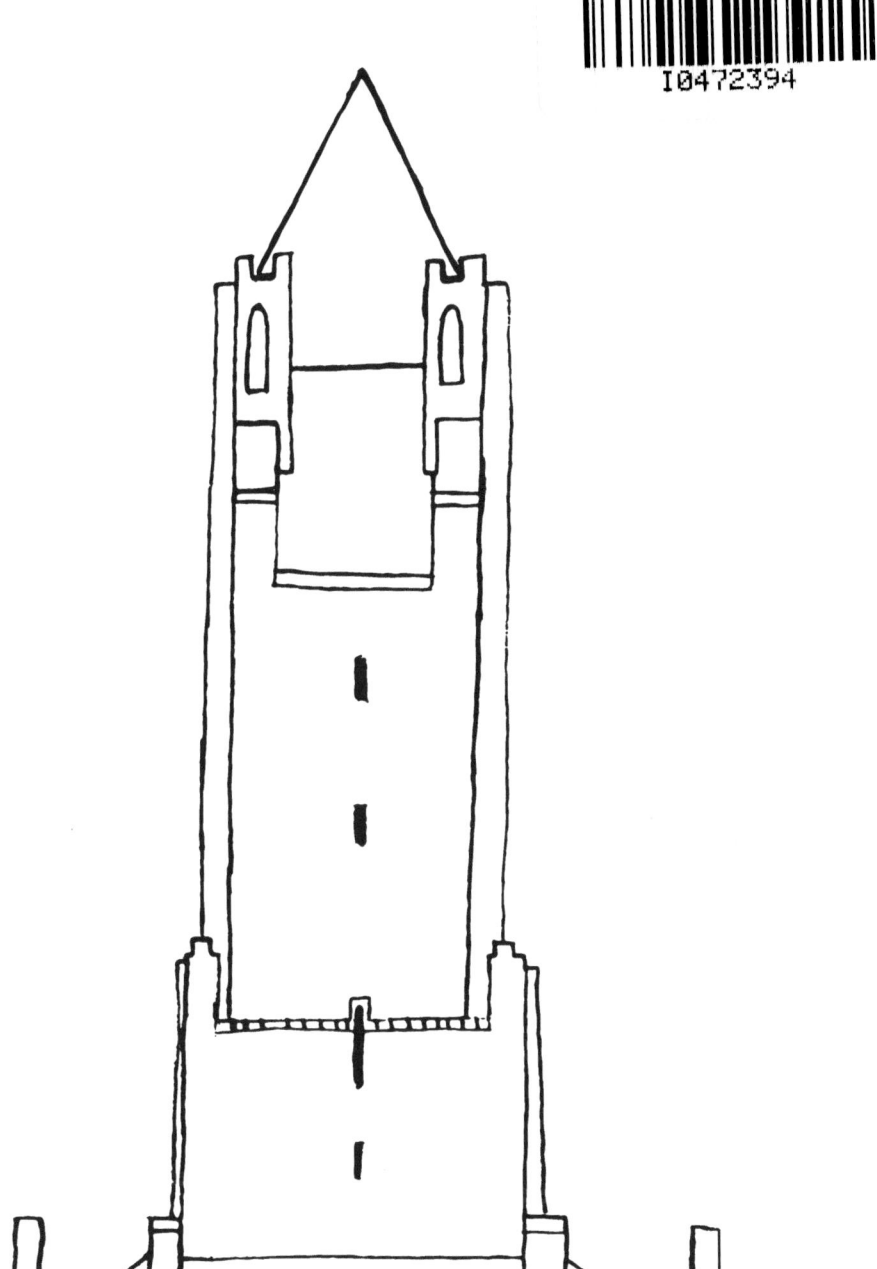

Secrets of Jones Beach

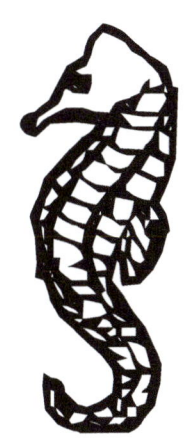

By Marlo Jappen

Copyright © 2014 by Marlo Jappen.
All rights reserved.

Text originally published by Newsday.com.
Edited by Carl Corry.
Cover image by Tricia Sullivan.
Illustrations by Joanna Olsen.
Typefaces from dafont.com.
Written and designed by Marlo Jappen.

ISBN: 978-1-312-68670-0
Printed in the United States of America.

Table of Contents

Introduction..1

Designed for the Automobile Class..................................3

It's a Working Water Tower..5

American Indian Culture..7

Hidden Messages at the Central Mall..............................9

Thomas Jones..11

Bathhouse...13

Theater Moat...15

'The Pier'..17

Trash or Treasure..19

Workout..21

A Wild Side...23

The Canvas Shop...25

Dressed the Part..27

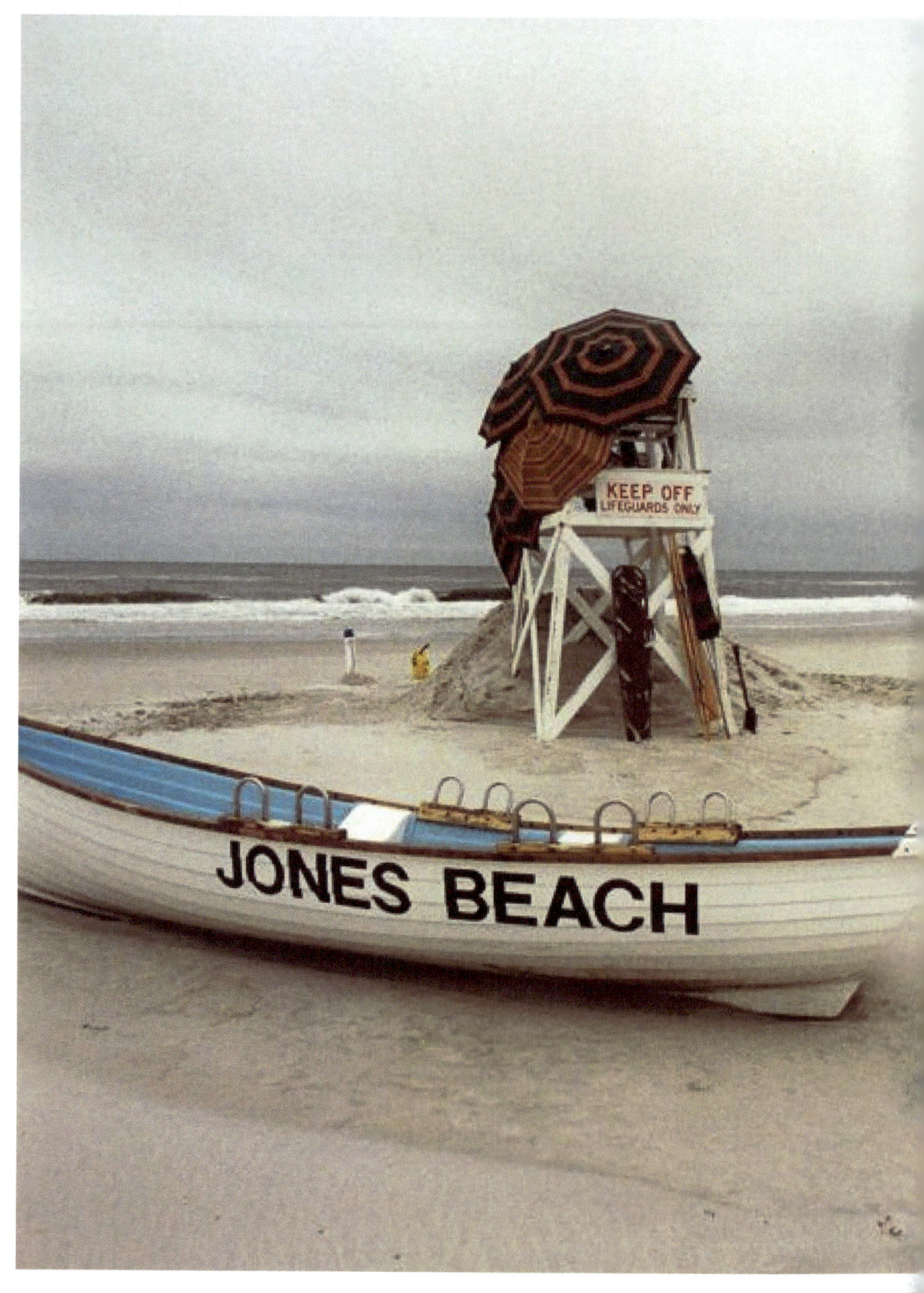

(Credit: Newsday / Bill Davis)

Introduction

In order to pursue his vision of creating a getaway for the middle class, Robert Moses transformed bleak swampland into a splendrous park system.

Jones Beach State Park, which opened in 1929, served as the forefront of his dream. Today, the park stretches across nearly seven miles and receives six to eight million visitors each year.

Yet no matter how many times you've soaked up the sun or strolled along the boardwalk of this iconic park, there are probably still things you didn't know about Jones Beach.

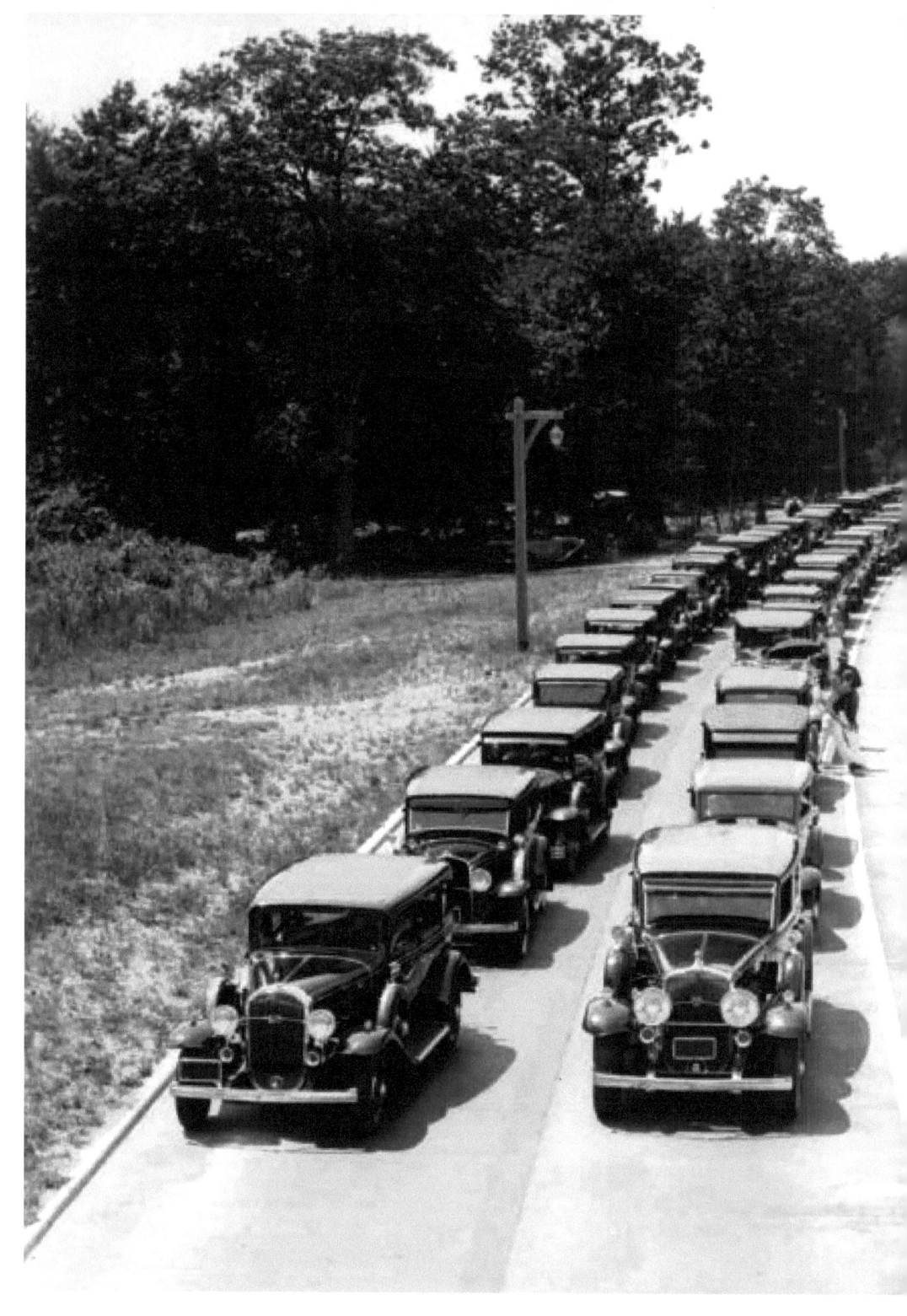

(Credit: Long Island Regional Archives)

Designed for the Automobile Class

Moses' vision for Jones Beach was meant for the automobile class, which at the time meant middle-class whites. Case in point: The highway system that leads to Jones Beach was designed so that buses could not fit beneath overpasses. And Moses vetoed a Long Island Rail Road proposal to construct a spur to the beach. Here, cars wait for the opening of the Wantagh Spur to Jones Beach on July 16, 1932.

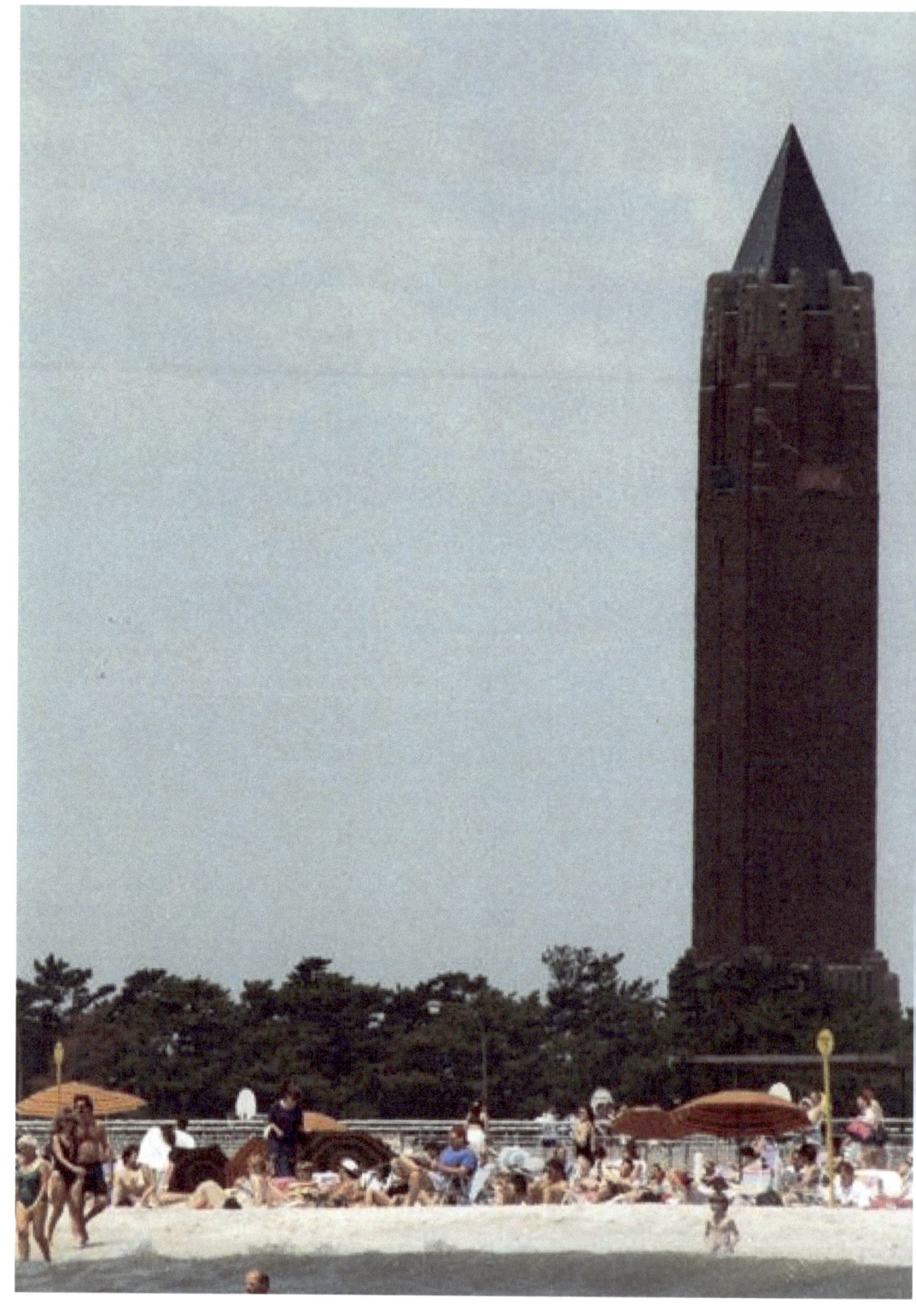

(Credit: Newsday / Daniel Goodrich)

It's a Working Water Tower

You can spot this famous 231-foot structure from miles away. Affectionately referred to as "the pencil," this tower was modeled after the campanile of St. Mark's Cathedral in Venice. Despite its name, many Long Islanders don't know that this water tower stores a steel cylinder that supplies 300,000 gallons of fresh water to facilities throughout the park, including all of the beach's swimming pools, restrooms, water fountains and the U.S. Coast Guard station. Since it was erected in 1930, the tower has been off limits to the public.

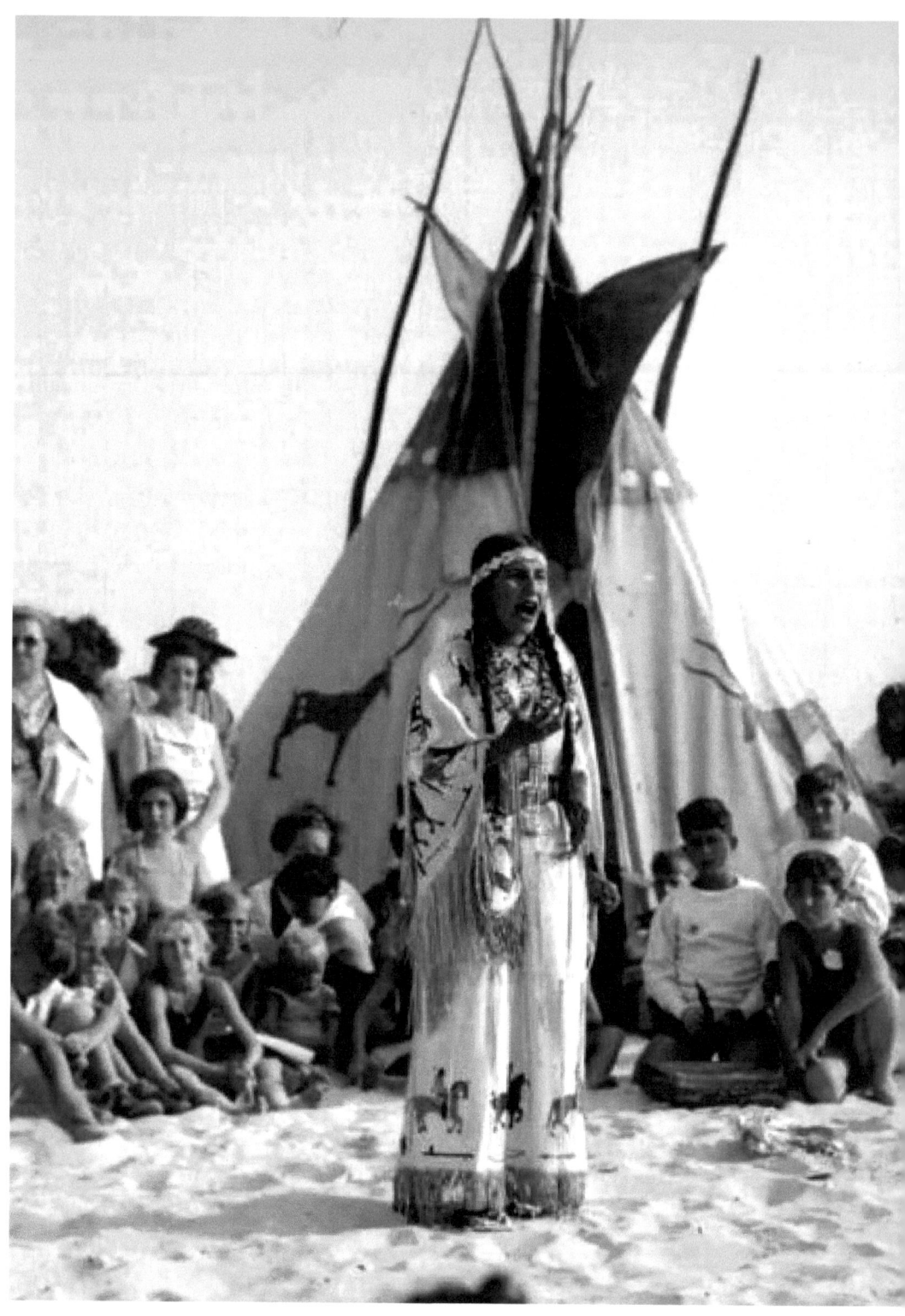

(Credit: AP)

American Indian Culture

Jones Beach once had an Indian village located on the spot of the current mini-golf course. Moses hired Rosebud Yellow Robe, a prominent member of the Lakota Sioux tribe (seen here in 1935), to teach archery at Jones Beach. She became the director of the Indian village and taught children about American Indian culture up until the 1950s.

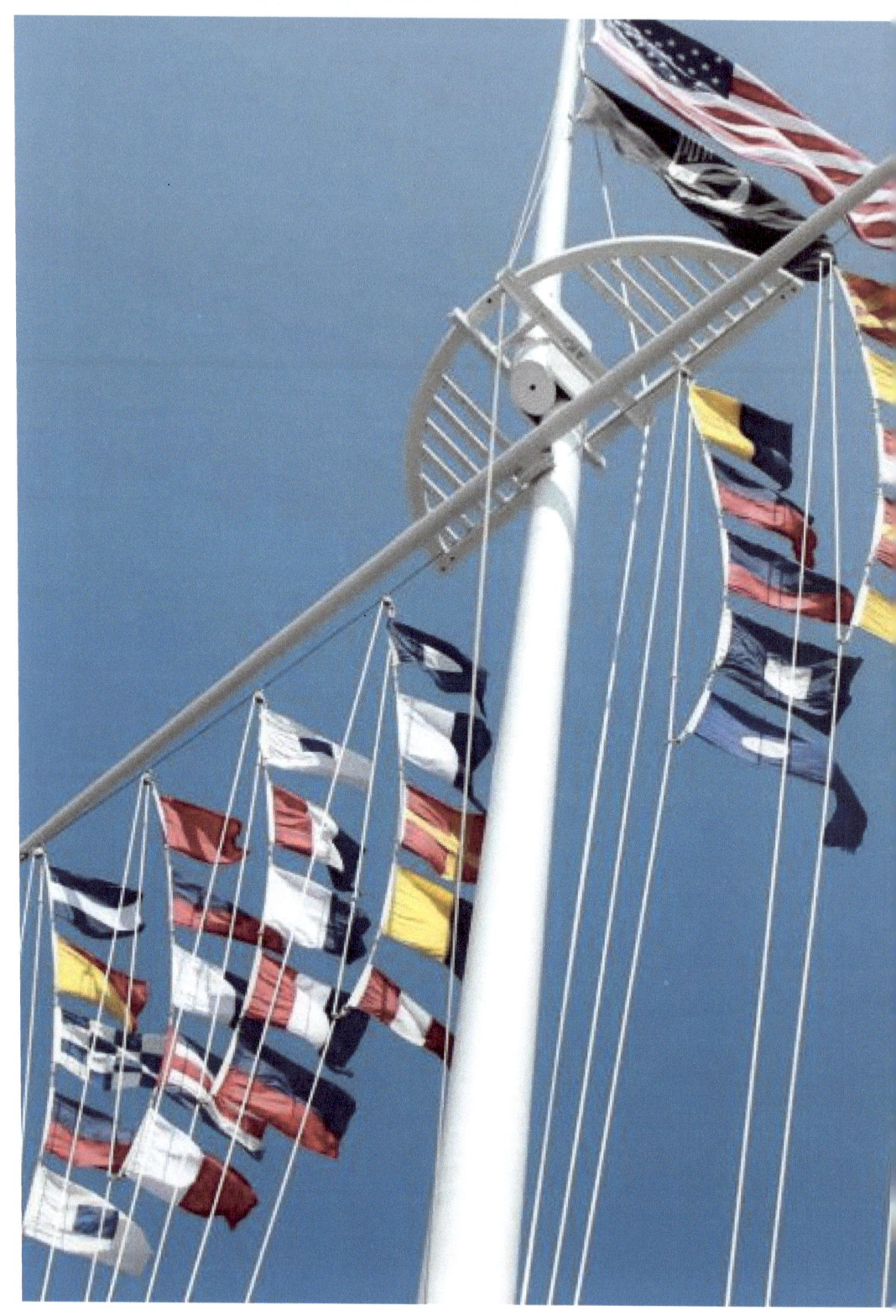

(Credit: Marlo Jappen)

Hidden Messages at the Central Mall

Upon entering the Central Mall, you will see a 90-foot ship mast decorated with marine signal flags that send out a message to boats in the Atlantic Ocean. Each of these colorful flags represent a letter in a mariner's code not known to the public that spells out "Jones Beach State Park" and "Keep Your Park Neat," followed by "2014."

Secrets of Jones Beach

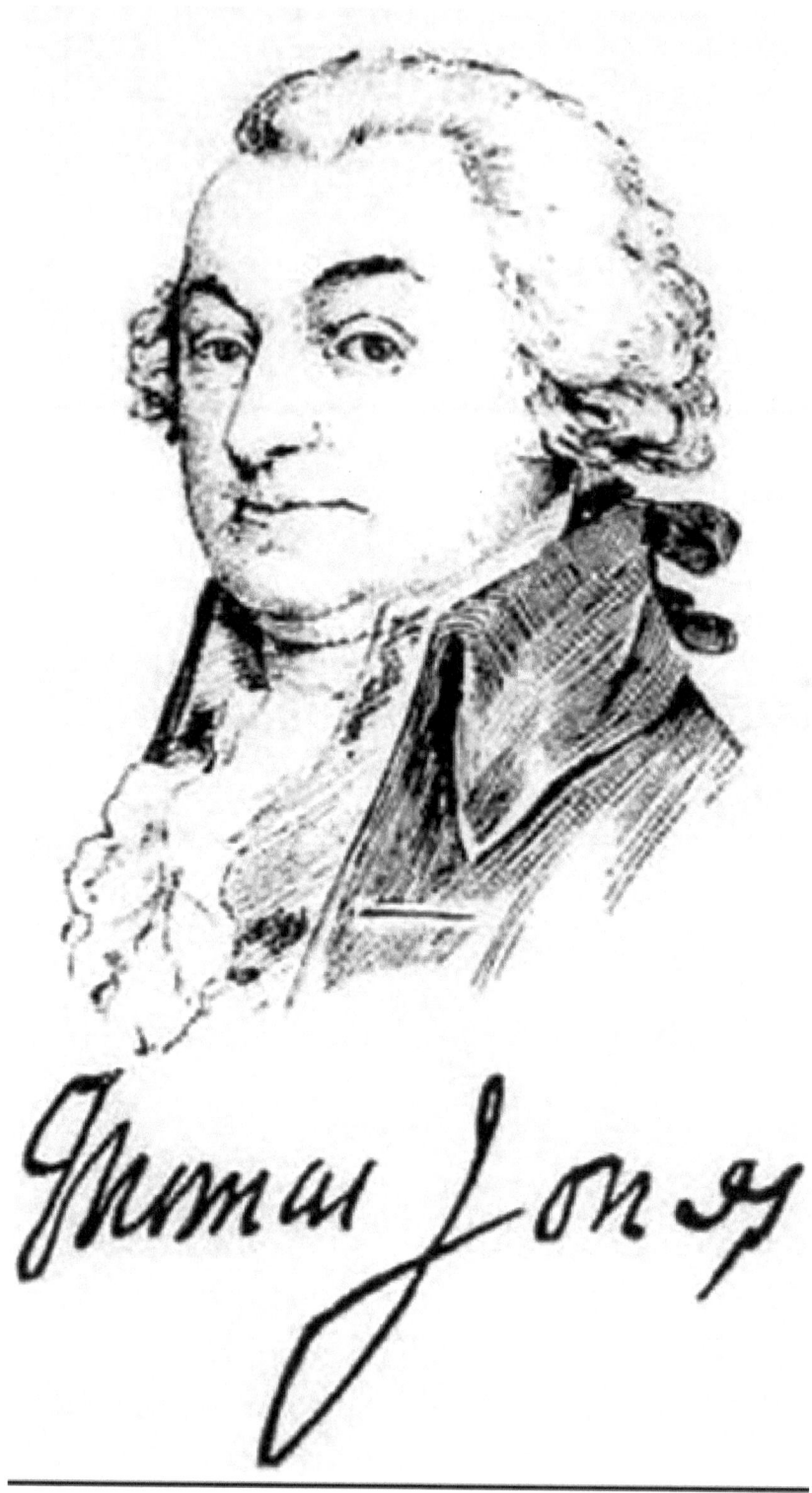

(Credit: jonesnyhistory.com)

Thomas Jones

Thomas Jones, the man after whom Jones Beach is named, was known as a successful whaler, a soldier in the Irish army and a major of the Queens County militia. And before he landed on the shores of Long Island around 1692, he was a privateer who looted ships of nations that were enemies of England's King James II.

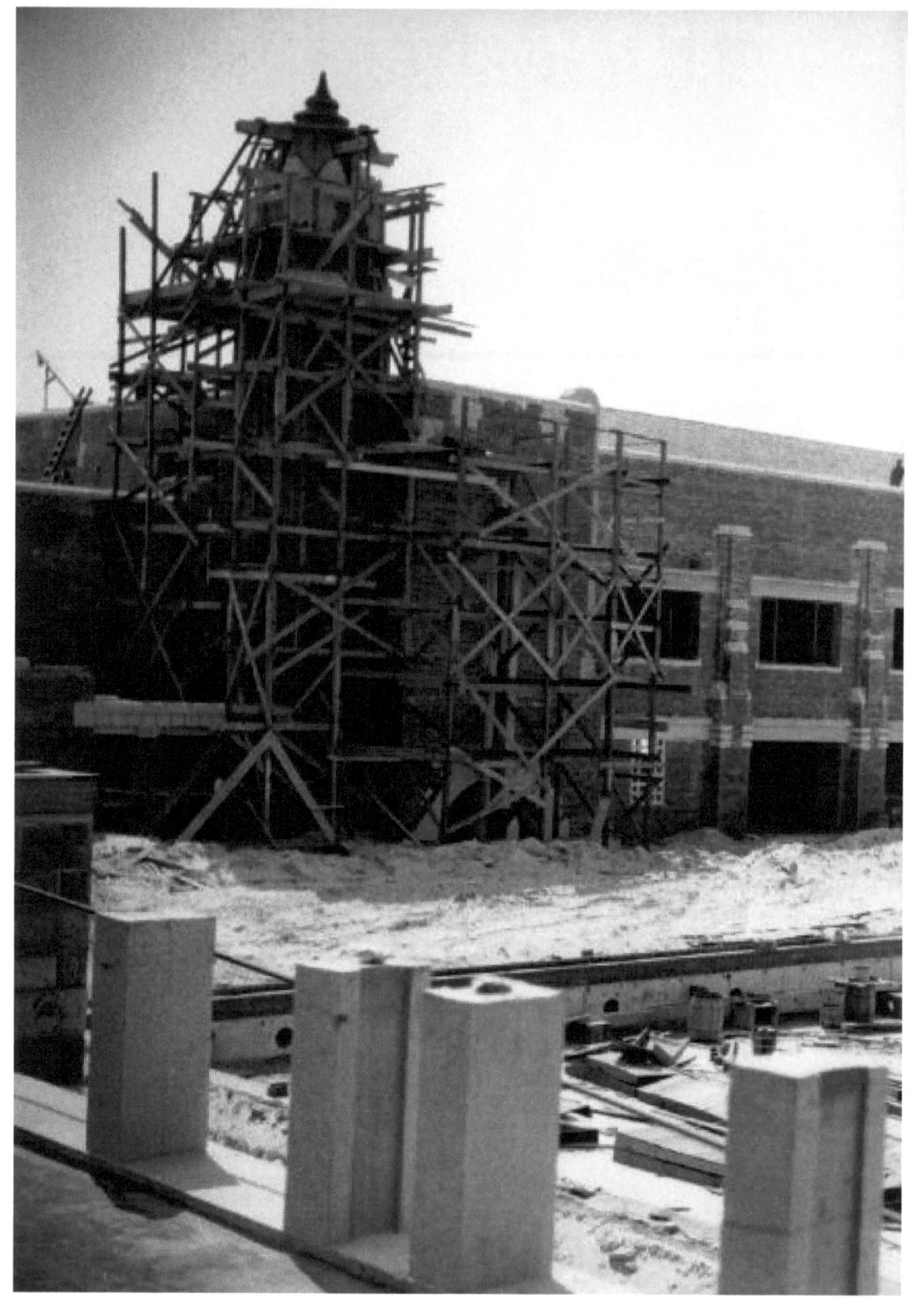

(Credit: New York State Parks, Recreation)

Bathhouse

The unenclosed heated pool at the West Bathhouse was originally intended to be used all year long. It's now only used during the summer season. Here, construction was underway in 1931.

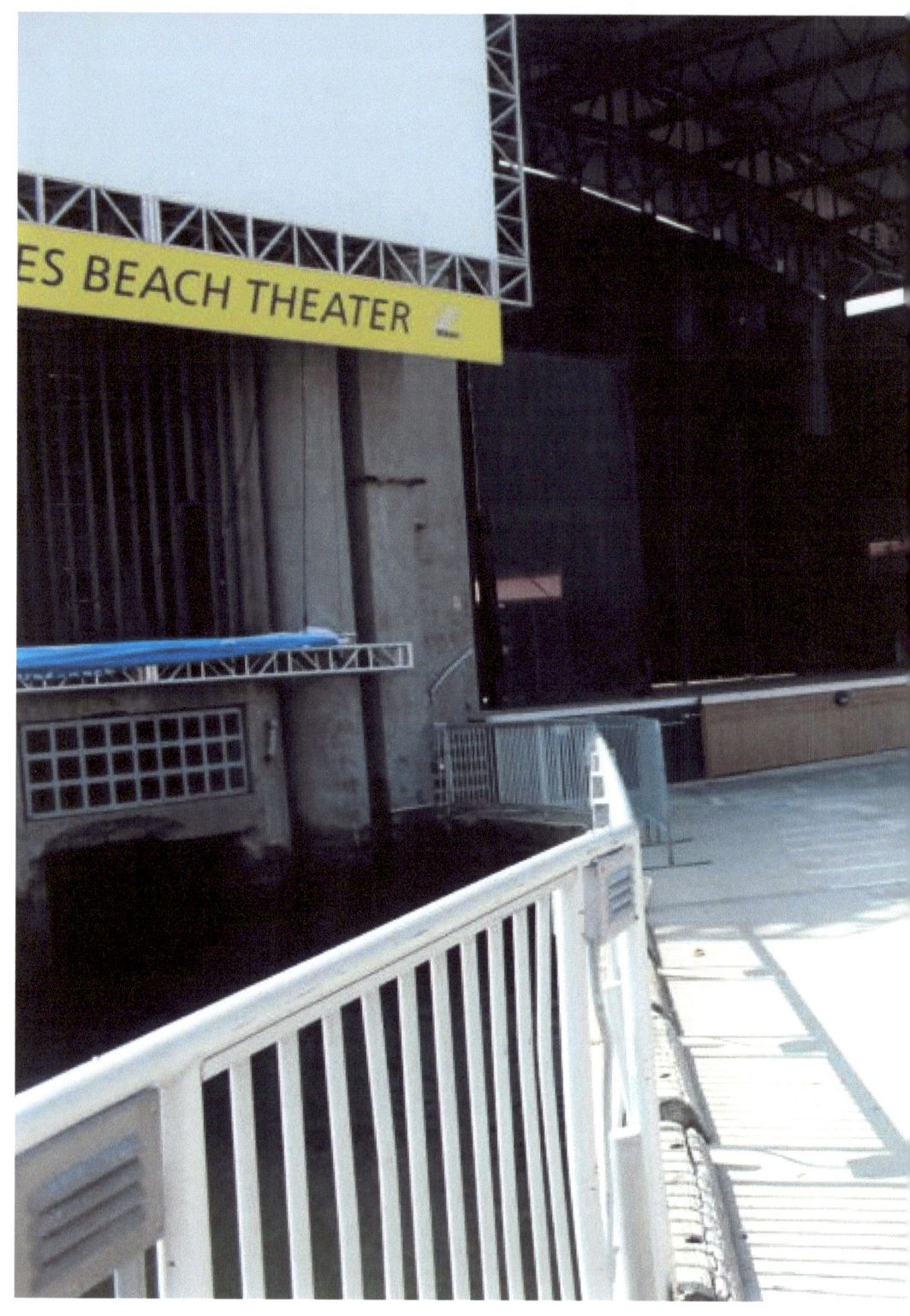

(Credit: Marlo Jappen)

Theater Moat

We know Nikon Theatre at Jones Beach as a concert venue, but this structure, which opened in 1952 as the Jones Beach Marine Theater, once hosted large-scale plays. A moat connected to the main stage was used to float scenery for set changes. In 1991, the moat was filled in to make room for additional seating.

Secrets of Jones Beach

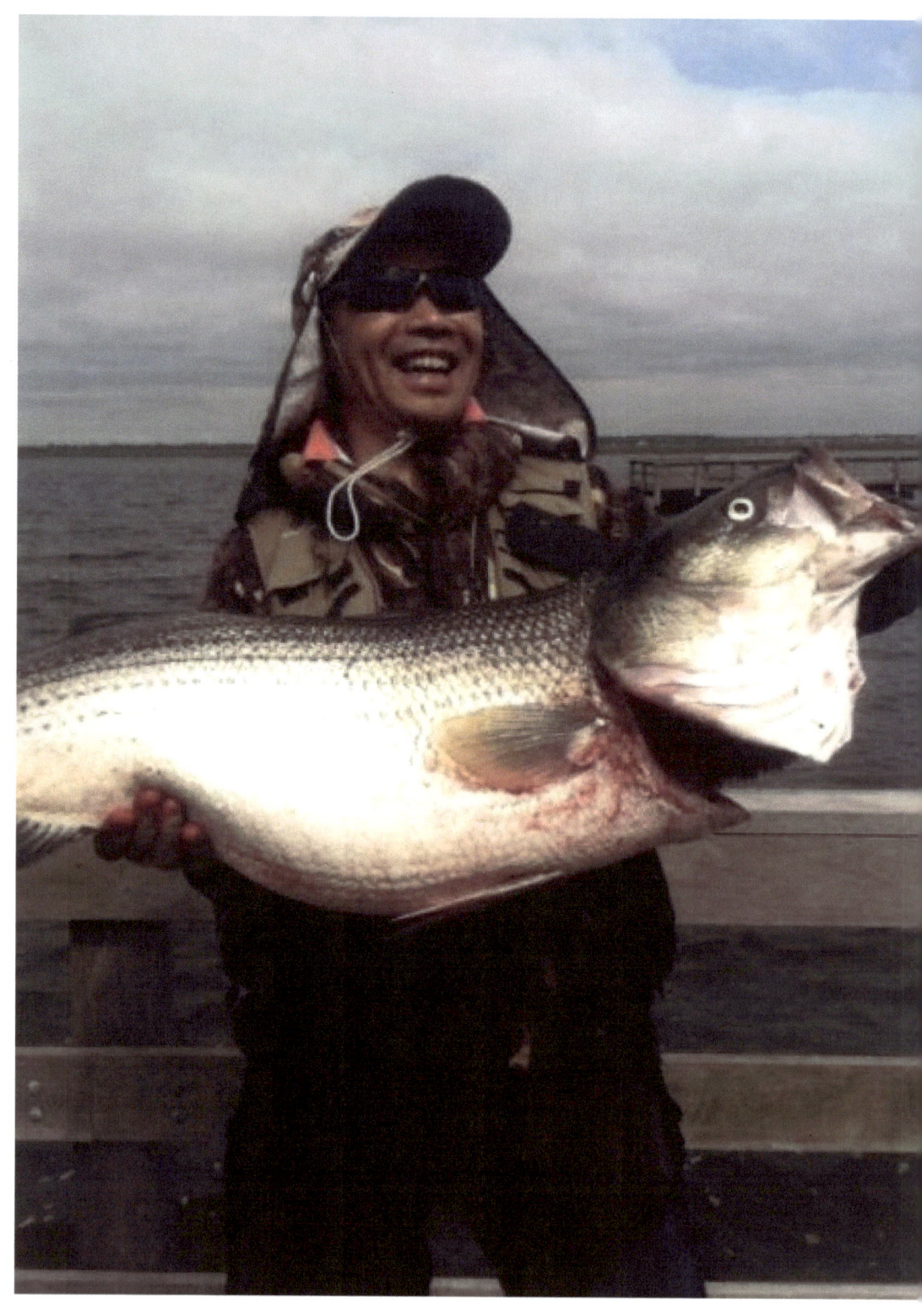

(Credit: Ed Walsh)

'The Pier'

During warm summer days, Field 4 and Field 6 are bustling with beachgoers who want to catch some rays. But Field 10, also known as "the pier," is more of a hidden gem. "People don't really know this exists," said Capt. Ed Walsh, manager of the Jones Beach Fishing Station. Walsh said anglers have caught sea creatures from this spot that many wouldn't expect -- including 250-lb. stingrays, tiger sharks and this 43-lb. striped bass pulled in by Jin Jun Li.

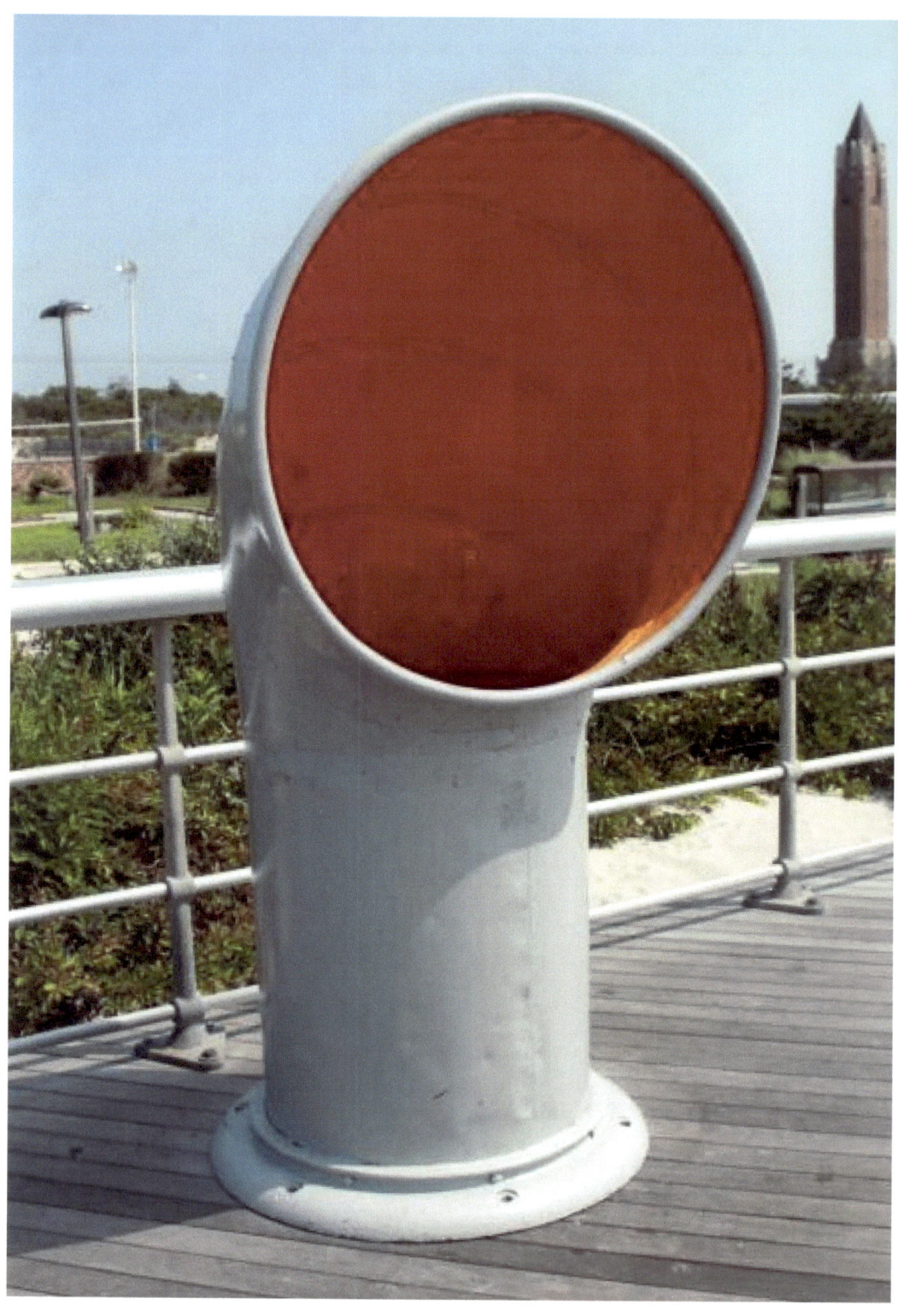

(Credit: Marlo Jappen)

Trash or Treasure

Robert Moses wanted visitors to feel as if they were aboard a cruise ship when they visited Jones Beach, so you'll find nautical flairs such as these funnels. They currently conceal trashcans, but they originally stored fire extinguishing equipment because Moses feared that the wooden boardwalk would one day catch fire.

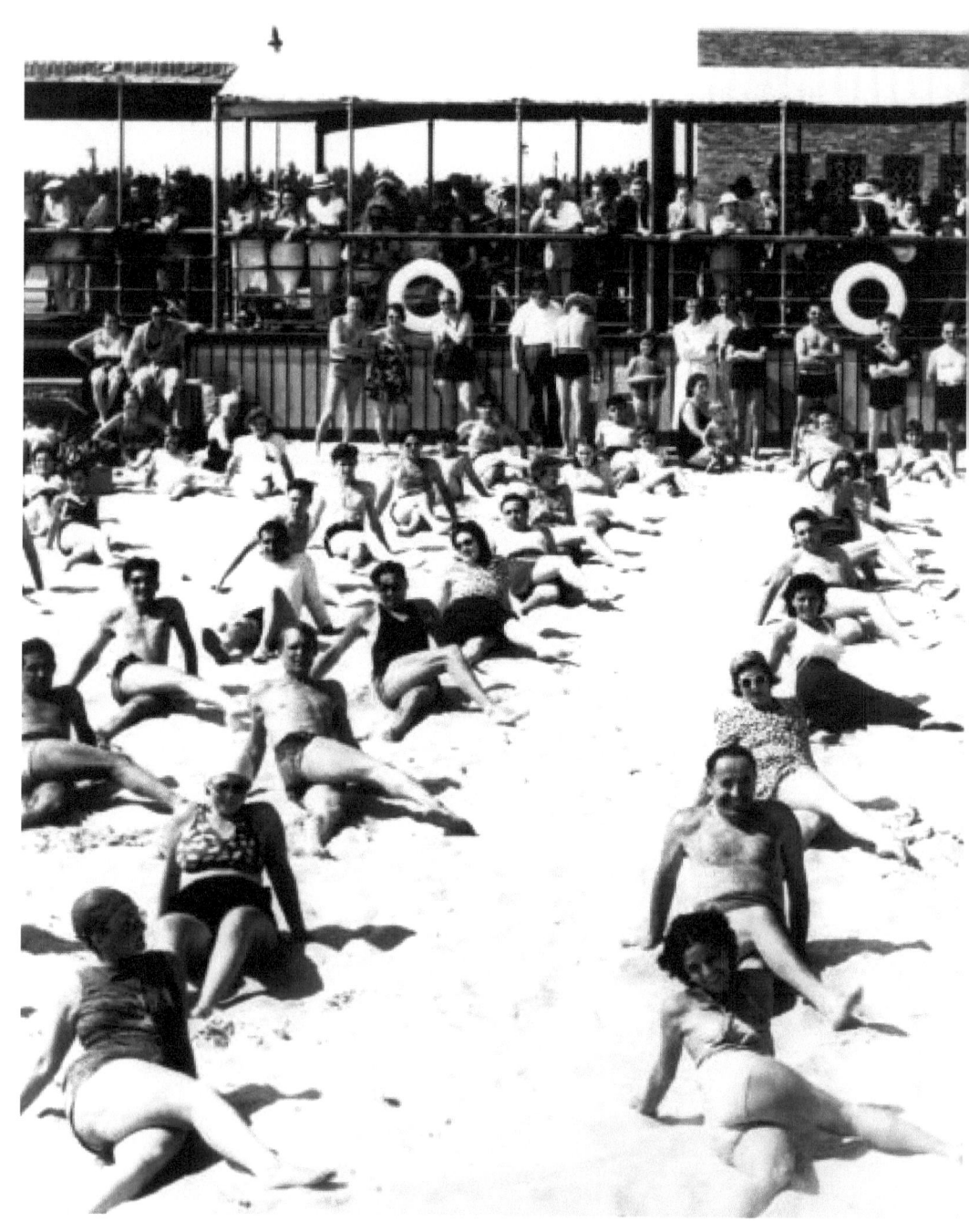

(Credit: New York State Parks, Recreation)

Workout

A series of exercise stations once lined the boardwalk from the Central Mall to field 1. Visitors would use the equipment to do sit ups, pull ups and other exercises. The park also hosted exercise classes in the sand, like this one in 1937.

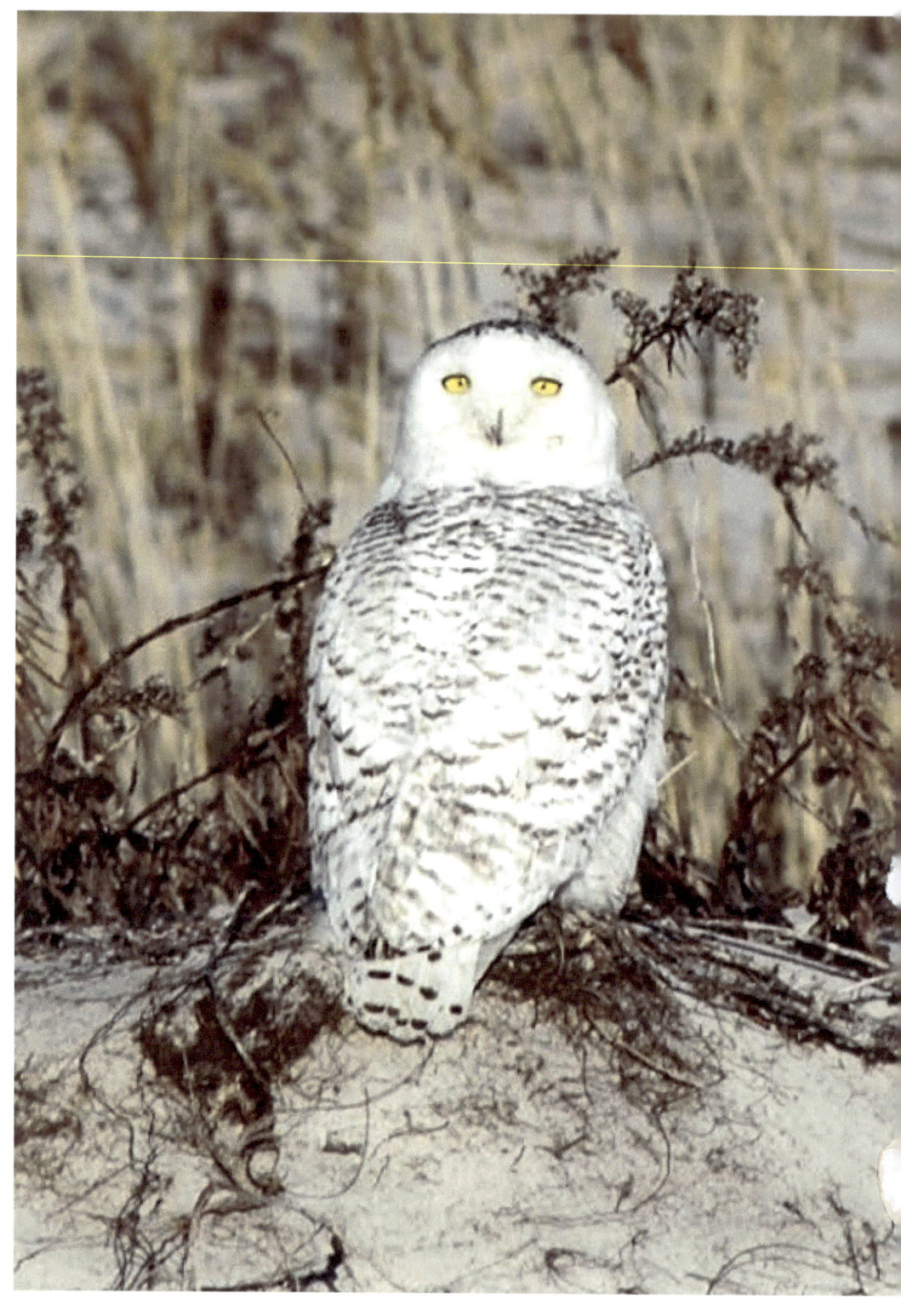

(Credit: Ed Walsh)

A Wild Side

With Jones Beach's close proximity to New York City, one wouldn't suspect it to be a source of shelter for wild creatures. However, various wildlife including snowy owls, harbor seals and piping plovers make their home at this park. Employees have tagged monarch butterflies found at the beach, and they have flown as far as the forests of Mexico.

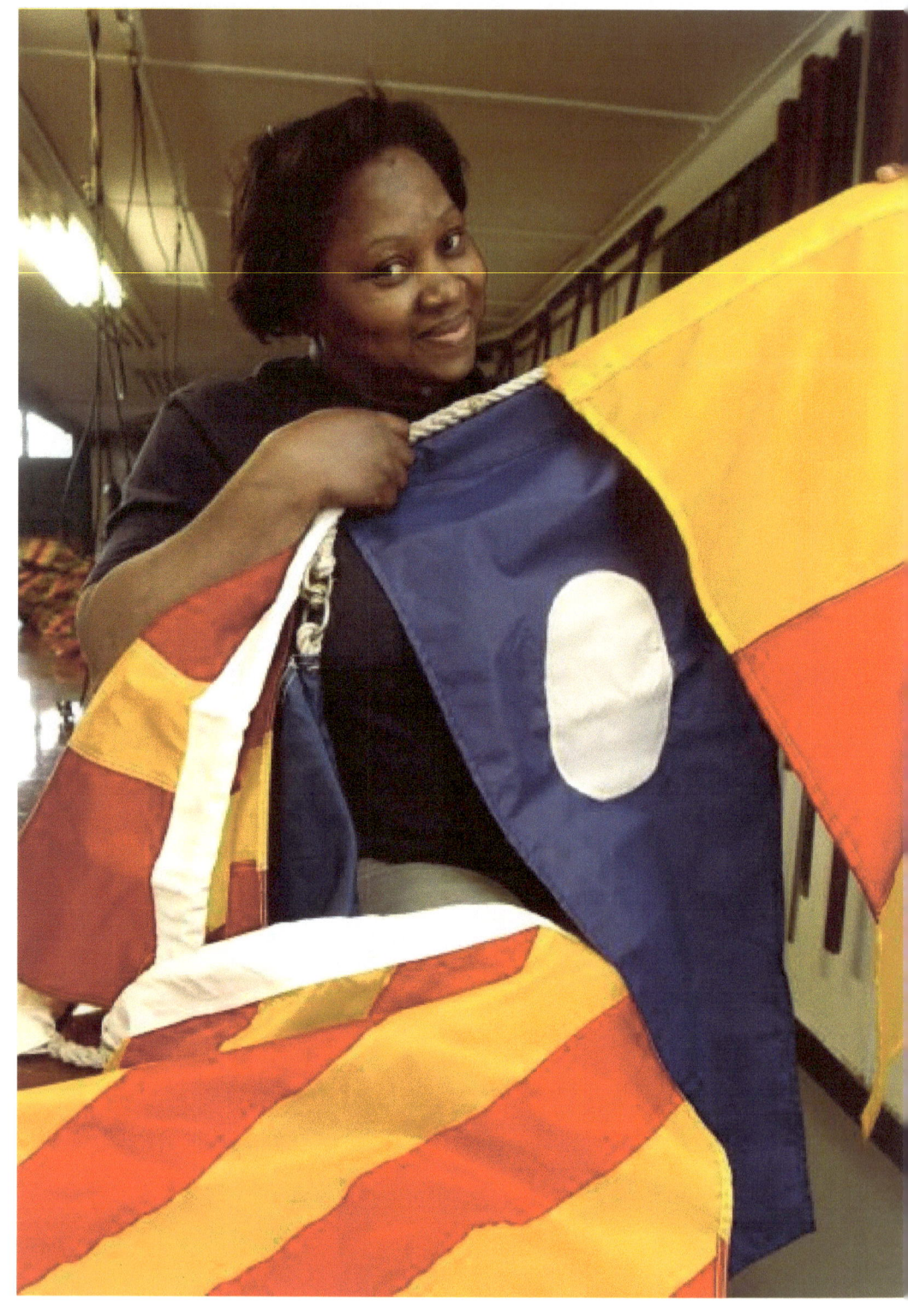

(Credit: Newsday / Michael E. Ach)

The Canvas Shop

Jones Beach has its own canvas shop, located in the maintenance facility at Field 10, which makes and repairs awnings, beach chair slings and umbrellas.

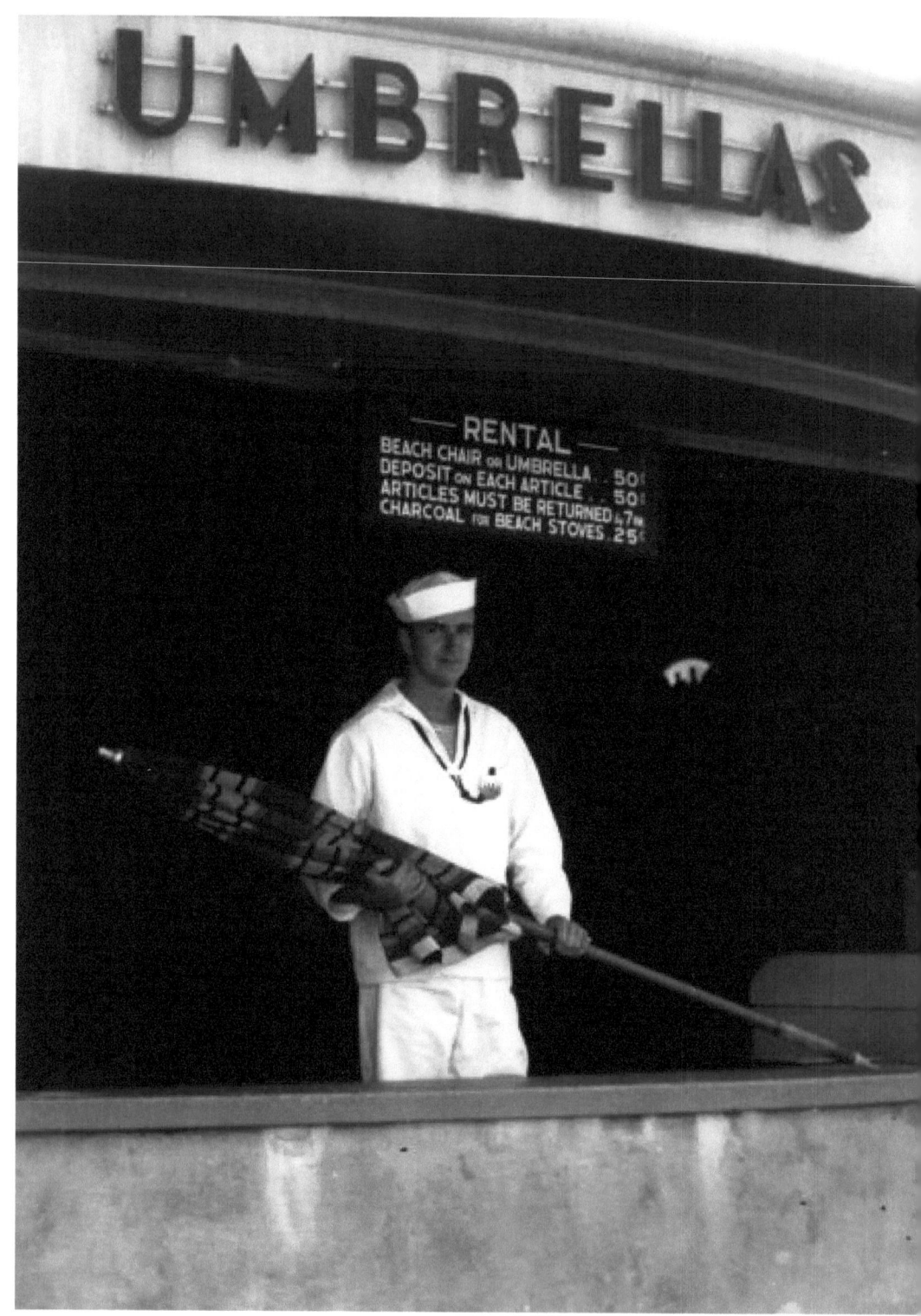

(Credit: New York State Parks, Recreation)

Dressed the Part

Robert Moses wasn't kidding around when he planned a nautical theme for Jones Beach. Staff members were once required to wear sailor costumes to reflect the maritime style that Moses implemented across the park. Although employees no longer sport sailor garb, nautical details such as the seahorse mosaic at the Central Mall still decorate the beach.

www.ingramcontent.com/pod-product-compliance
Lightning Source LLC
Chambersburg PA
CBHW041117180526
45172CB00001B/300